FRAGILITY

FRAGILITY

To Touch and Be Touched

**Marlies De Munck
& Pascal Gielen**

Valiz, Amsterdam

HUSK

A chestnut rolls past me in the garden. I follow it with my eyes. It stops, staying put, looking like a small carapace. Determined to prevent anyone from entering. I take a step forward. Stretch out my hand, but hesitate. If I want to reach the fruit, it will prick me. Leave it be. I'll not harm it. Yet I know that sometime its protective casing will crack. The husk lying there is just an advance guard. If the chestnut is to become a tree, it will have to permit itself to be touched. If it is to live, it will have to open up sooner or later. But the husk hesitates. So I wait as well. And gradually I realize that its strength does not lie in its spikes, but in its fragility. It's all a matter of timing. If it bursts open in time, it can take root. If it remains closed, it will die inside. Before my eyes, the chestnut hesitates: to touch or be touched?

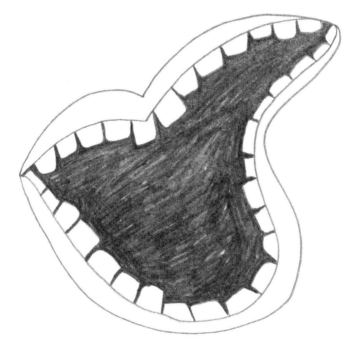

PROFILE

People have husks or protective casings too. They play a vital part in keeping out and allowing in. With a shell like that, there is no need for me to reveal myself. That is often a matter of survival. It provides a sense of security. I can use my 'husk' to overcome social obstacles. But if I live too long in a protective shelter, no-one will enter. The world cannot touch me, but neither can I touch the world.

And now the ambiguity of safe spaces becomes apparent. Human vulnerability demands such spaces—and rightly so—since they provide a reasonably good protection against such fragility. However, someone living in a safe space, no longer develops resilience to cope with the outside world. After all, it is the nature of husks to suspect whoever and whatever is different. Potential threats are lurking everywhere. Husks exist to avert threat. Yet if I see dangers everywhere, I risk shutting myself away in a lacklustre bubble.

These days, social media reinforce the formation of a protective casing. I'm constantly comparing myself with other people on Facebook. I seem, permanently, to be competing for more attention, more likes, more followers. That is why I present a happy, successful and ever-active image. Face = façade. Stammering, stumbling, fumbling or hesitating do not fit in with my decorous digital self. I meticulously keep the way

others can interpret me in check. After all, with my image, I am also risking my public self. If I look like a fake on social media, it could pursue me for the rest of my life. Our worldwide memory network never forgets anything. And so, I prefer to hide sensitive matters behind my profile. In the same way as in public space and at work, I present a filtered version of myself in the digital domain.

But if I retain that image for too long, it's as if I become alienated from myself. It feels as if I'm erasing myself, exchanging myself for an ideal image. With my digitally packaged version becoming my new self. Sometimes it feels comfortable. But if it lasts too long, I feel trapped. Listless too. Something I generally only notice after some scrolling. Soon everything feels more superficial and hollow. I touch briefly on other profiles and then they quickly slip away from me. My digital self is two-dimensional—literally and figuratively. I turn into my profile—derived from the Latin *filum*. Mere form or shape. Here we have the ambivalent essence of husks. They protect nascent life, but can also stifle it.

WALL

'My colleague's the one to deal with that. I'll put you through.' Nowadays the government prefers to treat me as a client. Civil servants compete with private companies in attending to my mail, healthcare and public transport. They compete with market players and other service providers in the same way my profile clamours for attention on social media. In a peculiar form of administration like this, private and public interests intermingle, while customer friendliness and state control shake hands with each other. With audits and monitoring, the government pursues a simultaneous carrot-and stick approach. And because now, as a citizen, I am seen as a client, I also behave as one. As a consumer, I feel both powerful and powerless. Professional ombudspersons take me seriously and listen to my complaints. And if they do not, I can always go to court. But the stronger my threats, the thicker the husk I must penetrate. The longer the digital form to be filled in and the longer the wait on the phone. Responsibility is repeatedly shifted from one person to the next.

At the turn of the nineteenth century, Max Weber still enthused about bureaucracy. For him, it just happened to personify reason in human matters. Bureaucracy mediates between what enters political life and what stays outside. When civil servants do their

work properly, they continually compare my individual preferences against the common interest. I can't have anything against this. Surely there is nothing more efficient than the management of existence and, in particular, co-existence? Today, however, that efficiency would appear to be the new ideology. A goal in itself, though I don't know to what purpose. It's as if reason has been exchanged for rationality, and rationality for rigidity.

The present-day administration, supported by an army of IT specialists, manages me through a complex labyrinth, to the rhythm of the algorithm. While the subservient servant evaporates before my eyes. No-one looks me straight in the eye. Not a living soul who tries empathetically to understand my question. Not that I want to romanticize the old bureaucracy. Of course, desk clerks used in the past to adhere sullenly to regulations and procedures. Yet the bureaucrat came face to face with me, with a small part of my life and my own concerns. That physical and multifarious relationship is the very thing that has been lost in digital bureaucracy. What's more, the resulting distance betrays fear of physical proximity. As well as fear of what can circumvent binary codes. Internet-connectivity knows no sensitivity. It is unable to deal with what is readable between the lines. An algorithm refuses to read between the lines. It is unable to differentiate between nudity and pornography. So how could it understand a human being?

From now on, the civil servant and I are two people, far apart from each other. Separated by a digital wall. More vulnerable than ever before, on both sides. And consequently, more enclosed in a carapace than ever before. Covid-19 has gone a step further. In the past, administrative rectitude and rules were supposed to protect me from arbitrariness. Today I collide with an arbitrary selection of ever-changing procedures and login systems. Rules mutate into measures that can change yet again, every day. For present-day bureaucracy I am not even a client. Not one of flesh and blood, but a set of data, be they processable or not. A data bundle which may or may not fit into the new algorithm.

And here again we encounter the ambivalence of creating a protective casing. Bureaucracy, in all its rational beauty, should protect a fragile individual, a vulnerable environment and nature. Good management should generate greater prosperity, greater wellbeing, greater equality and cleaner air. However, politicians nowadays seek refuge behind rules and procedures. Their 'husk' becomes harder and thicker. In this way, politics lacks its feeling for life. Perhaps the loss of sensitivity does not apply for the living beings who still circulate in the administrative apparatus. But it does apply for the procedures and digital systems they are constantly redesigning. They are at a loss about what to do with the concerns of life. An algorithm does not navigate and select on the basis of empathy

and meaningfulness. So, it starts to falter when real life enters. My unusual question or unexpected answer stalls the system. The person working the machine is the only one who can interpret and make sense of it. It may be a very logical structure, but a universe of ones and zeros can make nothing of a twisting life path. Franz Kafka warned way back: 'Logic may indeed be unshakeable, but it cannot withstand a man who is determined to live.'

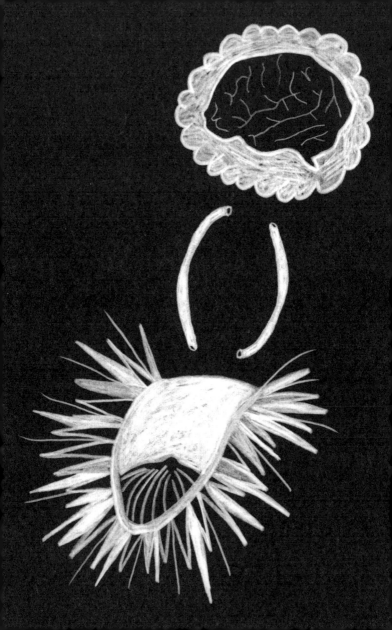

EVALUATE, INNOVATE, OPTIMIZE

It's that time of the year again. Yesterday the evaluation reports for the past academic year poured into my mailbox. They show how students have assessed your performance as a lecturer, for every subject. They are presented with all manner of parameters, graphs and open categories, and everything is duly anonymized. Time and again, I open the reports with a sinking feeling. And I repeatedly sigh with relief when the curves go in the right direction. But that one negative comment will inevitably haunt me more persistently than all the positive comments together.

Not that I want to sound petulant. After all, students must themselves also take exams. And in hierarchical institutions the less powerful must also have a voice. Yet it doesn't feel quite right. I am asked, at least once a day, to assess someone, somewhere. From the bicycle courier to the toilet at a motorway carpark—the latter by means of a convenient 'smiley' button. That entire evaluation circus is swathed in neoliberalism. The idea being that, thanks to the evaluations, you can optimize your teaching—or other activities. Purged of all shortcomings. Preferably deploying innovation. The horrible word 'quality care' always crops up somewhere in this enumeration of words.

Such care, so many good intentions, yet it all seems very bleak. What kind of idea will young people get if they are constantly asked to assess others? What ideal are we dishing up for them when we ask for 'suggestions for improvement'? How do the bicycle couriers feel when they receive their scores? And what should the cleaners think about all those angry smileys given by customers who leave the toilets dirty themselves? The idea that we can evolve towards an ever more perfect world, with ever better people, who do ever more their best to supply optimal services or products—is that not the greatest pitfall of the creed of progress? Who gains from it? What actually grows here?

At all events, not our mental health. Today it is apparent that mental health issues have increased apace among young people. It is a consequence of the Corona pandemic and the way we have sought to contain it. But the problem did not come out of thin air. Our mental wellbeing has long been under pressure, and not only among young people. There are reports on that subject too. Everything properly mapped out. But who maps out the cause of the real pandemic? Every culture has its own psychological problems, as the Belgian psychiatrist Paul Verhaeghe explained clearly. And I understood that he meant that you recognize the character of a society in its symptoms. To my mind, ours suffers from the compulsion to optimize. Perhaps that could also be measured at some stage.

DISTANCE

Recently, with the assistance of a few colleagues, I wrote a memo to the rector at my university. I tried to explain how the institution might connect better with the city and society. I already knew the rector's views on the matter, so his enthusiasm did not surprise me. However, the doubts soon arose. Why was it not possible for this highly dedicated man to carry through his views? After all, he's been at the helm for five years. Moreover, I spoke to several deputy rectors, who endorsed the necessity. So at least the rector has a few powerful allies. Yet the university largely remains an island in the centre of the vibrant life which it studies and about which it teaches young people something every day. Nowadays, committees of inquiry and research funds harp on about 'dissemination', 'valorization' and 'social impact'. Those far from poetic words would seem only to distance them further from society.

Distance is necessary, as I learned as a budding sociologist. Only by deploying appropriate methodology, is it possible to become conversant with social reality. And when saying or writing something about it, definitely do not forget to refer to all those who have gone before. Academic references and methods are the keys to knowledge about the world. They connect up everything that is already known with

everything as yet unknown. They ensure that academia survives, paradoxically enough by standing back a little from life. Distance is a good thing if you want to get to know the world better. René Descartes pointed that out some four-hundred years ago. He believed that knowledge was no longer to be found in a direct relationship with the world. Only if a living soul shakes off sentiment and emotion, will reliable knowledge be possible.

However, these days methodology and academic references get in my way to a growing extent. According to current academic norms, I may no longer count on intuition, empathy or 'viscerality'. And so I have ever greater difficulty asking those specific social questions I want to ask. According to the prevailing methodology, such questions are apparently 'unpredictable' even before you start. Not only do stringent methods spoil my appetite for the unknown, but the imposed academic language pulls the genie out of the bottle. Living language, conveying affection, enthusiasm and subjectivity—such language is now known as methodological sacrilege. Endless references prevent me from finding the right tone. Accordingly, the words I write are ugly and the sentences badly phrased.

For instance, how should I construe the comments on a text I recently wrote with a colleague for a scholarly book? The external editors thought it lacked source material for quite a few of the chapters. It could

do with more references. They did not specify where. General remarks like these are odd. Doubts were not cast on the book's content. So were we supposed to embellish references merely to enhance the academic image? In addition, one editor had problems with our assertion that 'at least some aspects of classical music, the fine arts or recent artistic experiments no longer resonate with life'. The reviewer considered that observation too great a generalization; research in progress would reach a more nuanced view. We were puzzled. Could you really measure 'resonating with life'? And wasn't our assertion sufficiently nuanced? We expressly referred to 'some aspects' of the arts. Should we have added a specific number? Our misgivings increased. Was our observation not scientific? Were we not good academics?

I find it increasing difficult to get used to this—and I'm not alone. I regularly encounter colleagues, who having worked in academia for years and no longer feel at home in the university. Be they philosophers, cultural scientists, sociologists or healthcare scientists. They feel more and more like strangers in their own habitat. Would the rector feel the same way?

Over the last two decades, the 'scientific business' has changed radically. The university has indeed become a 'business' in which rankings, international peer reviews and research funds are pivotal. Anyone hoping to succeed for a job or a promotion, must provide enough academic publications. And receive

grants. Social relevance and even pedagogical quality count for far less in a job interview. The growing demand for relations with city and society is diametrically opposed to an international academic community. There, academics encase themselves in their own world, which tolerates reality less and less. The surrounding urban or social reality is just too complex for precious time to be wasted on it. Let alone play a relevant role. Academic curiosity preferably does not extend further than the horizon of a research project—i.e. four or, at most, five years. Thus, what is academically relevant is reduced to what is quantifiable and feasible within that delineated period. A young researcher will not wish to deviate one millimetre from that path. Competition with colleagues is just too great.

Policy in universities not only makes researchers and lecturers vulnerable. It also affects the methods I myself use and the research-related questions I still dare to ask. They too must produce results and publications, fast. Personal ambitions may also lurk behind logical reasoning and objectifying methods. Social relevance conforms ever more to what may be thought and said within the constraints of an academic publication. Anything that does not count for my career, gradually vanishes from view as far as academia is concerned.

Accordingly, a university shuts itself up in a safe, but lifeless protective shell: its own reality, in which freethinkers and socially engaged intellectuals, as well

as intuition, imagination and empathy, are forced outside the walls. Even the culture committee of a research fund prefers to reward a chemist studying metal salts to, say, a phenomenologist testing embryonic speculations on art and life. Perhaps that is why quite a few people in the humanities decide they see better opportunities in neurology, technology and digital humanities. Not 'I think, therefore I am', but 'I count, because I am counted.' That would seem to be the academic production line's new adage.

Do I really have to measure the extent to which art resonates in life? It's like having to prove the quality of sex by the number of children it produces. But what does that say about love and life? Meanwhile, the doubts persist. Should I at last leap into the breach for 'town and gown'? Or would I be better off spending my time on a prestigious academic publication? One about Marx, art and engagement.

BARE

We are living in a time of mysophobia: fear of contamination. Corona may have something to do with it, but the tendency already existed before the pandemic. I first noticed it a few years ago, when a delegation of students declared they no longer wished to read certain philosophers. Of course, it was mainly a symbolic statement. I fully support the suggestion to make way for lesser known and more diverse authors. For me it's not a matter of either-or, but of and-and.

But there was more to it. A number of students proved to interpret the symbolic statement somewhat literally. The targeted thinkers really had to go. Apparently, those students feared contamination from exposure to unwelcome thoughts. To my mind, that is going too far. As if you couldn't help but sympathize with colonial abominations when you delve into Kant's and Hume's enlightenment thinking. As if, when reading Nietzsche, you would automatically develop a will to power. Thinking does not work in such a one-on-one way.

Of course, it's true that we are formed by everything we are exposed to in our life. That applies both to our thoughts and to our bodies. So we try to create the best possible environment. Every parent faces that challenge: to what do I expose my children and from what must I protect them? You'll soon be

inclined to do some 'weeding'. No sex and no violence. No hate speech or slander. No lies. No indoctrination... But no offensive caricatures? No divergent political opinions? No discordant ideas? No ugliness? No art by banned artists? No philosophy of white males?

If you aren't careful, this train of thought will soon land you in mental quarantine. Then, the sole aim is to keep your thinking pure. I fear that, for many, this has meanwhile become the meaning of a 'safe space'. But such a safe place serves to recover, to regain strength. Surely, it can't be the intention to spend your entire life in such a bubble? You will lose touch with the world. You build up no resistance in that way. You deprive your own thinking of its defences.

True, our thinking is fundamentally formed by exposure to other thoughts. But it does not make you defenceless against 'wrong thoughts'. To the contrary: the confrontation with what is disparate enables you to adjust and reinforce your own ideas. There is also healing in exposure.

SCLEROSIS

Over a year ago, Arne Herman, one of my doctoral students, received his PhD for his research into the musical canon. One of his conclusions was that, over the past century, the canon has been suffering from sclerosis. Orchestras keep on playing the same pieces by the same composers. Added to which, conductors and musicians seek to perform such music as faithfully as possible. *Werktreue*, as it is known in musicology. The canon has become a hard shell. You may still play the notes, but preferably without affecting them. The doctoral candidate cited increased competition as one of the causes of this sclerosis. Increasingly, major orchestras compete in the leisure sector with other cultural participants, and with one another. They can draw audiences with the canon. Concert halls fill up for Ludwig van Beethoven, less so for Olga Neuwirth. That is why orchestras prefer familiar works. The major ones observe what others are doing on the international scene, measuring their successes and learning from them. Consequently, their programmes tend to be much of the same. It works in the same way as Spotify. If I'm curious about new sounds, rhythms and melodies, I invariably end up with the same favourites. More and more of the same. The same old song.

Not that I object to a cultural-historical canon being played and taught. After all, it shows me the

way. A canon, as well as cultural values, standards and usages, are something to hold on to. They are my landmarks, guiding me through life. In a similar way to a bass line in music, they provide a grounding. No unnecessary luxury in a digital world through which I often surf groundlessly these days. A canon provides a helping hand, clarifying the meaning of images, sounds, words, colours and tones. Where they come from. How they came about. How, at some time, they have impacted on history. Revealing how they have moulded human beings, economics, politics and society. This is perhaps the best remedy against 'digibeticism', fake news, misleading advertising images and political propaganda.

A great deal depends on how that canon is learnt and presented. If there is too much emphasis on knowhow and knowledge, pupils will still be able to recognize a famous work of music or painting. They may even learn about the historical significance and context. And perhaps also be allowed to play a recorder. Let's hope they also learn how to draw perspective. But why is all that necessary?

It is time to learn how to look critically at one's own culture, and a canon—be it imposed or not—has less and less to offer education today. Knowledge on its own does not constitute a voice of its own. Education that presents the canon as an absolute fact actually limits true creativity and so authenticity as well. The cultural frame of reference then feels like a straitjacket

dictating a certain direction. But it prevents my daring and desire to create of my own accord. And eventually can indeed result in *Werktreue*.

I must learn to appreciate what I have never before heard, seen or read. To understand why my taste differs from that of others. Why it differs from a collectively supported canon. It is just as important to keep a culture alive as to remain creative myself. If I wish to be critical and create things myself, I must dare to take risks. Take a stance. Also, if I want my criticism to be heard and possibly have an impact. If I want my creation to 'work' within a culture or a community, then I need to be in touch with the complete spectrum of that culture. A well-founded canon can certainly be of use. But if I am to play with the rules of art, I should not only be able to summon those rules. I will have to get to grips with them. Embody them. An authentic creation, or even just the development of an authentic view. Such things assume that I dare to touch the canon. That is the only way culture and heritage survive. A canon only remains valid if its casing can burst open at the right time. It happens when it admits to its makeability and fragility.

VULNERABLE

I must admit I went with some trepidation to *Dance for Actress*, with the actress Jolente De Keersmaeker performing Jérôme Bel's choreography. Unlike her sister, the well-known Rosas choreographer Anne Teresa De Keersmaeker, Jolente does not have a trained dancer's physique. It might be embarrassing. When the actress opened awkwardly with a few pirouettes and allegros from her early dance classes, my intuition was all but confirmed. But I soon had to put aside my prejudice. In the next scene, De Keersmaeker portrayed the sleepwalking Pina Bausch from *Café Müller*. Fragilely naked. Moments later, when she held on to that fragility and went all out to Rihanna's *Diamonds*, I had changed my mind.

Umberto Eco asserted that a tear from the audience determines the difference between kitsch and art. If he had taken me as his barometer, he would have encountered a great deal of kitsch. I happen to be a weepy person. But does Eco's comment not mask a rational taboo against sentiment? Where is the cool customer who is not affected by human fragility? And, even worse, does art not have to affect us in order to be termed Art? Is art that does not relate to life actually living art?

Artists are already highly talented in fragility. They are even trained in it, as far as that is possible.

Letting the casing burst open at the right time. Anyone going on a stage, is making him/herself vulnerable. Performers are constantly balancing between what they reveal to the audience—and what not. They navigate between touching the audience and allowing themselves to be touched. When artists reveal too much about themselves, they lean towards exhibitionism, sentiment and kitsch. But if they give too little, they come across as sterile. And a performance tends to become either virtuosity without soul or pure formalism. Artists without a voice of their own lack authenticity. If they convey too much, their work acquires a somewhat obscene character. There is no need for them to publicize their innermost feelings. Vulnerability is also embodied in the form. In a personal movement idiom. In a specific brushstroke or in what Roland Barthes called the grain of the voice. Too much grain makes singing impossible. Too little produces only sterile sounds. The grain makes the singer fragile, but without it, it will be hard to charm the audience. Without that physicality, an art work might perhaps be 'interesting'. For instance, it can be intriguing because it illustrates a surprising idea. But that kind of idea does not affect me. I can't reach it and it doesn't work for me. Or, on the contrary, it is too easy to reach. Because I am able to comprehend it immediately, there's nothing left to envisage or feel about it.

Allowing the casing to split open at the right moment. For me that is an aesthetic skill—with aesthetics in the sense of *aesthesis* or sensory perception. It is the art of touching and being touched. It requires all the senses and affects. Artists need aesthetic talent not only to create appealing art, but also to understand a culture. Someone who is not sensitive to a culture, does not understand the cultural codes, cannot break them sensibly. In that case, artistic work remains meaningless or misunderstood. Yet aesthetic ability is more than understanding codes and symbols, and more than mere sensory perception too. It is hard to pin down in words, but an aesthetic experience is, for me, all about comprehending fragility. Whether it relates to a human being or a society, you can comprehend them if you succeed in penetrating their fragility. If you can strike a chord with them. It happens when you penetrate the space where life and transience meet. That is where vulnerability resides. Where you taste death within life, fear within self-assurance. Is that the origin of the expression 'loving someone to death'? You're crazy about someone because he/she lives. But you are aware of it because some weakness, a hint of death lurks behind it.

You sense the intertwining of opposites—life and death, strength and weakness, but also between the left and the right, friend and foe. For me, aesthetic skill is the ability to experience a faltering and fragile reality as a cohesive whole. It is about seeing the beauty of

someone even if he/she is almost falling apart while still managing to keep everything together. In the way a grammatically faulty sentence makes sense for that very reason. That is what I saw in *Dance for Actress*.

But why can an art work affect me so much? Possibly because I recognize my own fragility in someone else's vulnerability. With the concomitant acceptance as well. I only encounter myself when confronting someone else. Fragility is not only proof of transience, but also of connectivity. When I admit my own vulnerability, the other person has the opportunity to identify with it. That may well be one of the foremost challenges of contemporary art. To reveal its own fragility subtly in order to touch on our universal connectivity.

MERCY

The sunbeams bring mild, cautiously good news.
Spring appears to be on its way. About time, after
months of crisis. Many of us have done unexpected
things, clutching at straws, as it were. Many may well
have been upset by the sweeping and condemning
pronouncements reverberating throughout the whole
spectrum of politics and ideology. Pointless scuffles.
Verbal sparring matches, bluff poker perhaps—but, I
fear, primarily a considerable source of hurt feelings. It
was unnecessary, certainly if you consider that, in the
words of Rutger Bregman, most humans are good.

I don't know if it is true that most people are
really good. But I do like the recruiting power of such
a statement. If all goes well, it will not be mere wishful
thinking, but a self-fulfilling prophecy. Yet to ensure all
goes well, you must achieve an upward spiral, the will
to go along with a positive narrative. I fear the verbal
abuse in recent months has not been conducive to a
positive outcome.

But there is hope. The autumn colours make me
want to dust off an old word: mercy. *Erbarmen* in
German—perhaps best known from the splendid aria
'Erbarme dich, mein Gott' in Johann Sebastian Bach's
St. Matthew Passion. The aria follows straight after
Peter's betrayal. The plea is addressed to God and
would seem primarily to be an entreaty for sympathy.

But that is not the most powerful meaning of the word. To show mercy also means to take care of someone. When you sympathize with someone's pain or misery, you feel compelled to look after them.

I find that a nice thought for today. It is time to lick our wounds and show mercy. Not because all people are good, but because it is certainly true that most people blunder their way through life with the best of intentions. In that perspective I can recognize myself, I can sympathize with even those who have annoyed me most.

So show mercy. To boomers and Sunday shoppers, to blood-and-thunder preachers, to the woke and the not-so-woken. Have mercy on puritans and doomsayers, on specialists and improvisers, on leftists and rightists. Mercy even on politicians and managers, calculators, sweet talkers and opinion makers. They are all united by the simple fact that, inevitably, most people blunder.

INTERWEAVING

Keen competition has resulted in management, university, culture and I myself protecting ourselves in an almost impenetrable carapace. It's better to guard against vulnerability. In this way, we no longer touch the world, and vice versa. That growing inability is, to my mind, closely connected with the place we give to art and culture these days. Art has been banished to the leisure industry. Culture has been rationalized out of education. The horizon of our perspective has been reduced. We have been deprived of our sensory capacities. Accordingly, it will be increasingly difficult for a civil servant with no cultural baggage to make sense of things that do not follow the rules of efficiency. And it will be increasingly difficult for a researcher with no aesthetic talent to discern what falls outside his methods, references and career. And I, too, go on spinning out of control in my own bubble and profile. When culture is relegated to the hobbies shelf, our horizon of opportunities contracts. Meaning becomes narrower. A straitjacket, no longer permitting unusual associations and connotations. It means less creativity, basically less life—and less lust for life. In turn, aesthetic deprivation impoverishes the possibilities to touch the world. And, conversely, narrows down the ways in which the world can touch us.

The alliance between culture and aesthetics enables us nevertheless to see similarities and connections in fragmentation and contradictions. It has already taught me that management, university, culture, I myself and my garden are interwoven. That, in spite of our great differences, we might indeed share a common fragility. That sometimes we possess the same demons and desires. It all depends on our cautiously admitting them to one another. Breaking open the protective casing at the right moment. And it may sound naïve, but I still believe that artists can be of considerable help in achieving that. Precisely because they are well versed in demonstrating fragility. That is something I have remembered from Joe Biden's inauguration. Amanda Gorman! Her discourse on hope split the protective casing open. 'The hill we climb' had an almost literally disarming effect. She exposed human fragility in the centre of power. Vulnerability was held up like a mirror to politicians. That works like putting a rose in a gun barrel. This is the hardest way an art work can hit power.

SOURCES

'Husk' is written by Marlies De Munck and Pascal Gielen.

'Profile', 'Wall', 'Distance', 'Sclerosis', 'Vulnerable', 'Interweaving' are written by Pascal Gielen.

'Evaluate, Innovate, Optimize', 'Bare' and 'Mercy' are written by Marlies De Munck.

'Distance', 'Sclerosis' and 'Interweaving' enlarge on words and ideas from:

Marlies De Munck & Pascal Gielen (2022). 'We Still Have a Dream. A Plea for a Sensibly Audacious Science', *Antinomies* (forthcoming).

Arne Herman (2020). *Orchestrating Creativity. The Musical Canon as a Regulative Concept*, PhD Thesis, University of Antwerp.

Marlies De Munck & Pascal Gielen (2021). 'Kunst, canon en de ratrace naar de eindtermen', *Tijdschrift voor onderwijsrecht en onderwijsbeleid* 3, pp. 198-200.

Pascal Gielen (2021). 'The Power of Vulnerability: Art in the Digital Woke Age', *Afterall* 52, pp. 18-25.

'Mercy', 'Bare' and 'Evaluate, Innovate, Optimize' were first published in 2020 and 2021 as columns in *De Standaard*.

Marlies De Munck is philosopher of culture. She is specialized in the philosophy of music and teaches at the Philosophy Department of the Antwerp University. As a member of the Culture Commons Quest Office (CCQO) of the Antwerp Research Institute for the Arts (ARIA) she supervises research in the arts. De Munck frequently contributes op-eds to *De Standaard* newspaper and is the author of essays such as *Waarom Chopin de regen niet wilde horen* [Why Chopin didn't want to hear the rain], *De vlucht van de nachtegaal. Een filosofisch pleidooi voor de muzikant* [The flight of the nightingale. A philosophical plea for the musician], and *Ik zie bergen weer als bergen* [I see the mountains as mountains again].

Pascal Gielen is sociologist of culture, focusing on the political and social context of creative labour. He's based at the Antwerp Research Institute for the Arts (ARIA) of the Antwerp University. There he leads the research group Culture Commons Quest Office (CCQO). In 2016, Gielen was the recipient of the Odysseus Grant for excellent international research by the Fonds Wetenschappelijk Onderzoek (Fund for Scientific Research). Gielen is editor of the book series *Antennae-Arts in Society* (Valiz, Amsterdam). He has published over a dozen books on art, creative labour, and cultural politics.

Lotte Lara Schröder created the drawings and the book design of this publication. She studied at the Werkplaats Typografie, Arnhem (NL) and in other settings. Lotte is an artist and graphic designer, interested in ecological and natural phenomena. Her 'free' work consists of drawings, paintings, and collages, often combined with sound or objects. Het graphic design work is characterized by a strong connection with the content, and is informed by the same sources and a playful intuition, very much her own.

FRAGILITY

To Touch and
Be Touched

Authors
Marlies De Munck &
Pascal Gielen

Translation
Wendy van Os-Thompson

Proofreading
Els Brinkman

Design
Lotte Lara Schröder
@speculativepress
—ABC Arizona text
by Dinamo
—**Atlas Grotesk**
by Commercial Type

Drawings
Lotte Lara Schröder,
The Zen Garden, 2022
pencil, various sizes

Project Editor
Simone Wegman

Publisher
Valiz, Amsterdam, 2022
Pia Pol, Astrid Vorstermans
www.valiz.nl

Paper Inside
Schleipen Romandruk
Extra Weiss 90 grams 2.0

Paper Cover
Munken Print White
300 grams 1.5

Printing and Binding
Wilco Art Books
Amersfoort

Distribution
USA/Canada/Latin America:
D.A.P., www.artbook.com
GB/IE: Consult Valiz,
www.valiz.nl
NL/BE/LU: Centraal Boekhuis,
www.cb.nl
Europe/Asia: Idea Books,
www.ideabooks.nl
Australia: Perimeter Books,
www.perimeterdistribution.com

English Version
ISBN 978-94-93246-10-2

Printed and Bound in
the Netherlands

This publication has also been
published in Dutch:

KWETSBAARHEID
Over raken en geraakt worden
ISBN 978-94-93246-09-6
Valiz, 2022

Previously published:

Marlies De Munck, Pascal Gielen,
Nearness: Art and Education after Covid-19
ISBN 978-94-92095-86-2
Valiz, 2020

Nabijheid: Kunst en onderwijs na Covid-19
ISBN 978-94-92095-87-9
Valiz, 2020